IMAGES OF ASIA

Chinese Dragon Robes

TITLES IN THE SERIES

Series Editors, China Titles:

NIGEL CAMERON, SYLVIA FRASER-LU

Chinese Dragon Robes

VALERY M. GARRETT

HONG KONG
OXFORD UNIVERSITY PRESS
OXFORD NEW YORK
1998

Oxford University Press

Oxford New York
Athens Auckland Bangkok Bogotá Buenos Aires Calcutta
Cape Town Chennai Dar es Salaam Delhi Florence Hong Kong Istanbul
Karachi Kuala Lumpur Melbourne Mexico City Mumbai
Nairobi Paris São Paulo Singapore Taipei Tokyo Toronto Warsaw

and associated companies in
Berlin Ibadan

Oxford is a registered trade mark of Oxford University Press

First published 1998
This impression (lowest digit)
1 3 5 7 9 10 8 6 4 2

Published in the United States
by Oxford University Press, New York

© *Oxford University Press 1998*

British Library Cataloguing in Publication Data
available

Library of Congress Cataloging-in-Publication Data

Garrett, Valery M.
Chinese dragon robes / Valery M. Garrett.
p. cm. — (Images of Asia)
Includes bibliographical references and index.
ISBN 0-19-590499-0 (alk.paper)
1. China — Kings and rulers — Costume. 2. Courts and courtiers —
Costume. 3. Dragons in art. I. Title. II. Series.
GT1555.G365 1998
391'. 00951 — dc21

98-14200
CIP

Printed in Hong Kong
Published by Oxford University Press (China) Ltd
18/F Warwick House East, Taikoo Place, 979 King's Road,
Quarry Bay, Hong Kong

Contents

Preface

Conjuring up visions of gilded palaces, powerful emperors, and scheming concubines, dragon robes continue to delight and intrigue admirers of Chinese dress around the world, even as almost a century has passed since they were last worn. This small book aims to give to the beginning collector and those interested in Chinese costume a brief introduction to the development of dragon robes, from their use as informal dress in the Ming dynasty, through their increased status as formal robes for wear on official occasions in the Qing dynasty, to their metamorphosis into women's wedding attire in the twentieth century.

The term 'dragon robes' is a comprehensive one. It has come to include not only dragon robes, *ji fu*, proper, but also court robes, *chao pao*. These were worn by the rulers of the Qing dynasty, the Manchu emperors, princes, noblemen, and their wives, as well as the mandarins, both Manchu and Han Chinese, who carried out the emperor's instructions and assisted in governing China. Other robes and vests decorated with dragons are also mentioned here, such as those worn by Han Chinese women at weddings and other formal occasions, as well as image robes with dragons which were made for temple gods. How the robes were constructed and their different weaves and embroidery designs is discussed. There is also help on dating these robes, by showing examples of how the designs of the dragons and the surrounding symbols evolved throughout the Qing dynasty.

In every work of this nature, thanks are due to kind friends and colleagues who assisted in many ways. Anyone interested in Chinese dragon robes owes a debt of

gratitude first to Professor Schuyler Cammann for his pioneering work in the 1940s, and later to the research of John Vollmer. Other collectors, dealers, and historians who have always been generous with their help, which I acknowledge with gratitude, are Pat Frost, Chris Hall, Dr James Hayes, Judith Rutherford, and Verity Wilson. Naturally all errors and omissions remain my own responsibility.

Valery M. Garrett
Hong Kong

For Katy

1

Early Robes with Dragons

GOOD-NATURED AND BENIGN, yet powerful and dynamic, the dragon has been worshipped by the Chinese for thousands of years. Rising in the skies it brought forth rain, essential to a nation which relied on agriculture as its main economy. A symbol of masculine vigour and fertility, the dragon was believed to make an appearance in the heavens before the birth of an emperor and so became the emblem of Chinese imperial authority. The emperor, referred to as the dragon, was clad in robes decorated with dragons and sat upon a dragon throne in front of a screen emblazoned with dragons. So important was this supernatural beast that it came to represent China itself, appearing on coins of the realm as well as the national flag.

The dragon was composed of parts of many other creatures. It had the head of a camel, horns like those of a deer, the eyes of a hare, and a neck like a snake. The scales on its body resembled those of the carp, its claws were like an eagle's, and its paws like a tiger's. On each side of its mouth were long curling whiskers; when it spoke its voice boomed out like thunder, while its breath brought forth fire or rain.

Ming Dragon Robes

Dragons first appeared on robes in the Tang dynasty (AD 618–906) and then again in the Song (960–1279). But it was the Mongols, who ruled China during the Yuan dynasty (1279–1368), who established their use, and as a result the conservative Han Chinese court in the Ming dynasty

(1368–1644) did not adopt the dragon robe officially, although they were worn for informal occasions.

The standard form of Ming dragon robe was a voluminous gown with wide sleeves, a round neck fastening over to the right, the whole girdled with a narrow hooped belt with jewelled plaques which denoted rank. Made with as much as 12 metres of silk, these cumbersome robes were unsuitable for anything other than the sedentary and scholarly lifestyle of the Ming court.

Two main dragons on chest and back extended over the shoulders, as is seen in a portrait of a Ming nobleman (Fig. 1.1), and later dragons spread down the sleeves as well. More important, and therefore more coveted, was a second style, in which the two dragons were visible on the chest and back, with two more on the outside of the sleeves, while above the hem of the skirt was a horizontal band

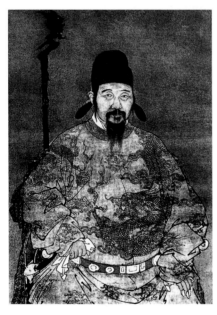

1.1 Li Zhen, also known as Duke Cao, wearing the first type of five-clawed dragon robe. Early Ming.

with pairs of smaller dragons at back and front (Plate 1). At the hem of the robe waves curl beneath the dragons, while in the centre, separating the dragons, a mountain rises up.

Colour was an important means of distinguishing the robes of the imperial rulers from those worn by their officials. Yellow, which stood for centre and the earth, was restricted to the use of the emperor. Red symbolized summer and the south: it became the dynastic colour of the Ming, and so high officials wore red robes. Lower ranks wore dark blue, which represented spring and the east, or green, which was considered to be a shade of blue. White represented autumn and the west and, as it was associated with death, was seen as an unlucky colour. Black stood for winter and the north and was worn by imperial bodyguards and principal attendants to the emperor.

A portrait of the first Ming emperor, Hongwu (r.1368–98), shows him wearing a yellow robe similar to those worn by Yuan officials. Two large dragons form what appears to be a large collar: the head of the first on the chest has its body looping over the left shoulder, the tail finishing on the back, while the head of the other dragon is on the back, the tail appearing over the right shoulder. Around the skirt is a horizontal band with a pair of dragons. The heads of the dragons on the upper part are front-facing, and this is the start of the tradition for the emperor, and later his most favoured courtiers, to wear dragons which faced the onlooker, while other noblemen and officials wore profile dragons.

Dragons coiled in roundels, a design feature which had possibly died out in the Yuan, was revived in 1405 when it was officially announced that informal wear for the emperor should be yellow with gold dragon roundels on each shoulder and on the chest and back. The emperor's sons,

and grandsons by those sons, wore the dragon roundels on red robes. Then, in the reign of the Xuande Emperor (r.1426–35), twelve large roundels were worn: four on the upper part as before, plus four on the skirt at front and back and each side, and one on the front and back of each wide sleeve.

During the reign of Tianshun (r.1457–64), another stage of the development of the Ming dragon robe commenced, with eight roundels visible on the outer robe and four on the inner robe. These roundels were arranged with four on the upper body of chest, back, and shoulders, and two each, arranged vertically, on the centre front and back of the skirt (the other four were placed vertically in pairs at the sides of the inner robe), as is seen in a portrait of the Taichang Emperor (r.1620)(Fig 1.2). Down each side of the skirt are visible the Twelve Symbols of Imperial Authority,

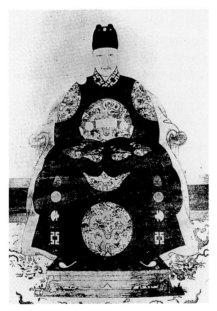

1.2 The Taichang Emperor wearing a robe with eight dragon roundels on the outer robe and four on the underskirt, and bearing the twelve imperial symbols at each side at front and back of the skirt.

which are explained in more detail in Chapter 5. Robes worn by Taichang's predecessor, Wanli (r.1573–1620), show another variation, with all twelve roundels visible on the outer robe, placed with four on the upper body as before, two on the front and back of the skirt, and two more on each side of the skirt.

The emperor and his sons could wear various styles of robes, and other types of dragon robes gradually came back into general use by nobles and officials. Five-clawed dragons, known as *long*, were confined to the use of the emperor, his sons by the empress, and other high-ranking princes, but they could be awarded on merit by the emperor to important nobles and officials. Four-clawed dragons, called *mang*, were worn by other princes, noblemen, and all those holding senior appointments in the court and household. They were also given as presentation robes for chief courtiers and high officials.

Dragon robes became very fashionable in the early years of the sixteenth century, with many officials ordering them freely and ignoring the laws of 1459, which forbade anyone from having such a robe made for himself. A decree of 1537 restated this restriction, and so officials tried all the harder to have the right to wear a dragon robe conferred upon themselves. By the beginning of the seventeenth century conditions were lax and it was again easy to do so.

Very few Ming robes have survived intact to the present day, probably because their owners were buried in them, as the gowns were highly prized and it was an honour to own one. To demonstrate one's high rank, it was essential to arrive in the next world in one's finest and most important attire. Most of the robes that have survived from this era had been taken into Tibet as gifts and recut into the narrower-sleeved Tibetan *chuba* style.

The Manchu Court

The Great Wall, initially an achievement of the Qin dynasty (221–207 BC), had been built to protect the fertile regions of central China from barbaric nomads who lived to the north. Invasion from outside the wall was a constant fear during the Ming era, as the country began to be threatened by the Manchus, a confederation of settled tribesmen of Tungusic descent, together with some semi-nomadic Eastern Mongolian herdsmen from the region now called Manchuria. The Manchus raised reindeer, hunted, fished and trapped animals for a living, and traded sable furs and ginseng with the Ming army along the Liaodong peninsula. In order to control the tribesmen, the Ming bribed the Manchus with dragon robes, as well as titles and other favours.

Fighting between the Manchu tribes made Nurhaci, from the Aisin Gioro clan, the head of the numerous clans, and the title of brigadier bestowed by the Ming Chinese made him supreme chieftain of all Tungusic tribes in Manchuria. His successor, Abahai, formally took the name Manchu for the collective tribes and attracted Chinese border troops into the Manchu army. After his death, his younger brother Dorgon acted as regent for Abahai's young son, who would later reign as Shunzhi, and continued his rule.

By this time a Chinese rebel army had captured Beijing, an event which culminated in the suicide of the Chongzhen Emperor (r.1628–1644) in the palace gardens on Coal Hill. Ming border troops from the Great Wall returned to Beijing to defend it, and Dorgon bribed the defending general Wu Sangui with a princely title and promised punishment for the rebels. General Wu allowed the Manchus through the Great Wall, and Dorgon and his army entered Beijing on 1 June 1644, setting up his nephew Shunzhi (r.1644–61) as the first Manchu emperor.

The Manchus named their new empire Qing (1644–1911), meaning 'pure', and the emperors, together with their wives, consorts and concubines, dowager empresses, plus several thousand eunuchs and female servants, took up residence in Beijing within the Forbidden City, which had been built during the reign of the Ming emperor Yongle (r.1403–24). Outside the palace walls, in the Imperial City, lived other members of the royal family. Surrounding them were the lower-ranking Manchus, while the Chinese people were moved to an area to the south of the city.

The Manchu rulers' intention was to follow the system of governance already in place under the Ming dynasty, but to improve the quality of life by injecting better standards into an inefficient and corrupt government. Gentry status was controlled through the examination system and the sale of ranks and appointments, and it was through this group of Manchu and Chinese men that the officials known as mandarins were selected. There were two orders of officials: the first, and more highly respected, were the civil mandarins, scholar officials who administered the government of China; the second order were the military mandarins who were responsible for the internal stability and the external defence of the country.

The mandarins were stationed throughout China and totalled at any one time about 9,000 civil officials and 7,500 military officials, of whom the majority were Han Chinese. In addition, there were up to 1.5 million members of the gentry class who had passed the difficult civil service examinations and were waiting for an appointment as a mandarin, as well as those who obtained rank and/or a degree by purchase, especially prevalent towards the end of the dynasty.

When the Manchus conquered China they comprised only 2 per cent of a total population of almost 150 million. Their

small numbers meant measures had to be taken to maintain control over the large native population. As part of their attempts to unite the country, the rulers imposed their own style of dress on all those in authority. Regulations first set down in 1636, before the conquest, were revised and extended in 1644, and again in 1652.

Robes with dragons, presented both as gifts and as bribes from the Ming court, were already familiar to the Manchus. Thus, despite their determination to impose their own culture and customs on the conquered Chinese, they did adopt the pattern of the dragon robes, if not the shape of them. The Manchus, having been hunters, developed their own style of clothing from the skins of the animals they caught. The sedentary lifestyle exemplified by the ample Ming robes was abhorrent to the Manchus, and they recut the cumbersome and impractical robes into a slimmer Manchu style to suit their more active way of life.

The five colours favoured by the Ming rulers continued to have symbolic properties for the Manchus, and they adopted blue as their dynastic colour. Use of red was generally avoided, as it had been the dynastic colour of the Ming, and henceforth it was only worn by the emperor for the annual sacrifice at the Altar of the Sun. However, with its connections with the Ming rulers, it was considered a lucky colour by the Han Chinese and used extensively by brides at weddings and for celebrations.

The Illustrated Regulations

By 1759, the Qianlong Emperor was sufficiently concerned that Manchu costume was being diluted by Chinese style that he commissioned the *Huangchao liqi tushi* (Illustrated precedents for the ritual paraphernalia of the imperial court),

which was published and began to be enforced in 1766. This was a work of eighteen chapters covering such subjects as ritual vessels, astronomical instruments, musical instruments, state regalia, and military uniforms. In particular, there was a long section on the dress of the emperors, princes, noblemen, and their consorts, as well as of Manchu officials and their wives and daughters. It also included instructions relating to those Han Chinese men who had attained the rank of mandarin, and their wives, as well as those waiting for an appointment.

The complete manuscript in its original form is thought to have consisted of about 6,000 illustrations and approximately 5,000 pages of text describing the objects illustrated. These are painted in fine detail in their correct colours on honey-coloured silk mounted on stiff card measuring approximately 40 centimetres square, with the corresponding text in black ink appearing on the attached left panel. Each illustration is captioned and the caption reappears on the adjoining text page, thus making up a single folio. The costume section alone is thought to have consisted of more than 20 volumes, each volume containing approximately 30 folios.

After the illustrations and text were completed, probably by late 1760, they were then distributed to the relevant government boards in the capital. The Board of Rites, for instance, would have kept copies of the chapters on sacrificial vessels and musical instruments; the Board of War held the chapters on military uniforms and equipment, while the Board of Civil Office had the sections on costume. The emperor, of course, held a copy of the complete manuscript.

A woodblock print edition, first appearing in 1766, was produced by the printing office at the palace. Relevant sections were distributed to officials stationed around the

country for their reference. To avoid discrimination it had been suggested by a Chinese official that both Han Chinese and Manchu officials should wear identical dress (Cammann, 1952:21). Thus all mandarins wore Manchu-style robes for formal occasions such as government business, celebrations, and festivals. However, Chinese officials were allowed to wear their own Han Chinese-style robes for informal occasions. All males, young and old, adopted the hairstyle of the Manchus: the long queue or pigtail.

Clothing was divided into official and non-official categories, then subdivided into formal, semi-formal, and informal. Thus, official formal and semi-formal clothing would be worn at court, while official informal dress was for official travel, some court entertainment, and for important domestic events. Non-official formal dress was worn for family occasions. Additionally, there were rules governing the changing of clothing according to season, the timing of which was dictated by the Official Gazette from Beijing. This stated the month, day, and hour that the emperor would change his clothing from winter to summer and vice versa. At the stated time all those wearing official dress must then follow suit and penalties were imposed on those who did not.

2

Qing Court Robes

THE *CHAO PAO*, or court robe, figured with dragons was the most important Qing robe and was worn for all momentous ceremonies and rituals at court. Its wear was restricted to the highest in the land: members of the imperial family, nobility, and high-ranking mandarins. Worn together with the *pi ling* collar, hat, girdle, and necklace, it formed the *chao fu*, literally 'court dress', and was designated official formal wear.

Men's Court Robes

To form the *chao pao*, the Manchus imposed some of their nomadic features on the bulky Ming robes. The garment was cut across the middle just below the waist. The upper part was narrowed at the underarms and became a short side-fastening jacket with a curved overlapping right front, which could have derived from animal skins added for extra covering and protection. It fastened with loops and toggles, again nomadic in origin.

The lower skirt was reduced in width to fit the upper part by forming it into a pair of pleated aprons joined to a narrow waistband. This changed form continued to give the necessary impression of bulk traditionally associated with festival dress, but the result was a less cumbersome garment than before. At the side of the waistband was a small square flap called a *ren*, whose original function, it is thought, had been to cover the fastening.

One alteration made to the long, wide sleeves of the Ming robes became a standard feature of Manchu robes.

The sleeves were cut above the elbow and the lower portion replaced with plain or ribbed silk, thought to have evolved so that the wearer could bend his arm more easily when hunting. The ribbed silk indicated the folds which occurred when the sleeves were pushed up the arms. Cuffs resembling horses' hooves, originally made to protect the hands when riding in bad weather, continued to cover the hands on formal occasions during the Qing dynasty, when it was considered impolite to show them.

Around the neck was the flared collar known as a *pi ling*. This feature may have developed from a hood which had been opened out along the top of the crown to extend beyond the shoulders. It is always shown together with the court robe in the Regulations. Usually embroidered or woven with one front-facing and four profile dragons, with a border around the edge, it was attached to the top button of the court robe or fastened independently.

The colours of the court robes were carefully controlled and, as before, certain colours were restricted to the use of the emperor and his immediate family. Bright yellow was reserved for the emperor, although he could wear other colours if he wished or as the occasion demanded. Orange or 'apricot yellow' was worn by the heir apparent; while 'golden yellow' was for the imperial princes. Third- and fourth-degree princes and noblemen wore blue unless they had been given the honour of wearing 'golden yellow' by the emperor. Blue was worn by the lower-ranking princes, and officials. Civil and military officials wore blue-black.

Rules for clothing were also in accordance with the season, and changes were made from fine silks in summer through to padded or fur-lined satin for winter, and from one season to another on a set day on the issuance of a decree. A portrait of the Kangxi Emperor (r.1662–1722) (Plate 2) shows him wearing the full court attire for

summer. His yellow satin robe is edged with brocade and decorated with dragons over the chest and back, while above the band on the skirt is a row of roundels. Around his neck is a chain of beads, on his head a conical hat with thick red floss fringing and a tall gold finial studded with sixteen Manchurian pearls. Across his shoulders is a *pi ling* matching the robe, and tied tightly around his waist is a yellow silk girdle from which hang purses and kerchiefs. All these accessories are carefully detailed in the *Huangchao liqi tushi* together with the corresponding robes.

There were three styles of men's court robe: two for winter wear and one for summer. The first style of winter

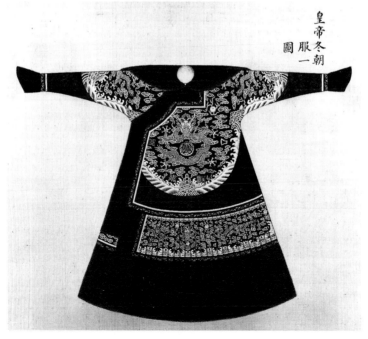

2.1 Painting on silk of the emperor's first type of winter court robe, faced with sable on the cuffs, collar, side opening, and hem.

13

chao pao was lined and lavishly faced with sable on the cuffs, side-fastening edge, *pi ling*, and with a deep band of the fur around the hem. The painting on silk in Figure 2.1 is from the Regulations and shows the emperor's first type of winter court robe. This style was restricted to the imperial family, the first three ranks of civil mandarins, and the first two ranks of military mandarins because of the amount of fur used and its scarcity.

The second style of winter *chao pao* and the summer one were the same in design; only the fabrics used were different. The second winter style was trimmed with otter fur, and the one depicted in Figure 2.2 is in red satin to

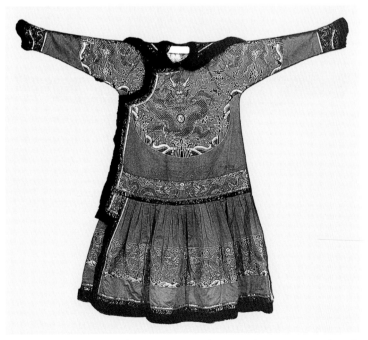

2.2 The second style of winter court robe, in red satin trimmed with otter, worn for the sacrifice at the Altar of the Sun.

Chart 2.1 First Style of Winter Court Robe after 1759

Rank	Colour	Dragon Placement
Emperor	yellow (blue for ceremony at the Altar of Heaven)	four front-facing *long* placed on chest, back, and shoulders; six *long* on front and back of skirt, placed one front-facing and two profile; twelve imperial symbols on upper part
Heir apparent	apricot yellow	as above, but without the twelve imperial symbols
Emperor's sons	golden yellow	four front-facing *long* on upper body; four profile *long* on skirt: two on front and two on back
First- and second-degree princes	blue, brown or any colour unless golden yellow was conferred by emperor	as above
Third- and fourth-degree princes and imperial dukes	as above	four front-facing *mang* on upper body; four profile *mang* on skirt unless conferred *long* type
Chinese dukes and other nobles; first- to third-rank civil officials; first- and second-rank military officials; first-degree imperial guardsmen	blue-black	four profile *mang* on upper body; two profile *mang* on front and back of skirt

be worn for the sacrifice at the Altar of the Sun. The summer robe was made of satin or gauze and edged with brocade.

Like the Ming robes, early Qing court robes had the large

dragon curling over the shoulder, with one on the back curling over the opposite shoulder, while the pleated skirt had the band of dragons around it above mountains and crashing waves. An example of an early Qing summer court robe (Plate 3) for a mandarin has two profile *mang* dragons on chest and back, and four on the front and back skirt.

Following the laws of 1759 (see Chart 2.1) first- to third-rank civil mandarins, and first- and second-rank military mandarins, were permitted to wear the first-style winter *chao pao* in blue-black, with four profile *mang* on the upper body, and two profile *mang* on front and back of the skirt. The second style of winter and the summer *chao pao* (see Chart 2.2) were also in blue-black and were worn by the first four ranks of both groups of mandarins. In this case, the upper part had four front-facing *mang*, while the lower part of the skirt had four profile *mang* at front and back.

Court robes worn by the emperor and crown prince had above the band of dragons on the front and back of the skirt a row of nine and seven roundels, respectively, containing coiled dragons. No one else was allowed to wear roundels on the skirt, although they did make an appearance on robes belonging to lower ranks towards the end of the dynasty. Plate 4 shows a summer court robe belonging to an official in the mid-nineteenth century. It is made of dark blue satin and embroidered with gold couched dragons, satin-stitch clouds, and Peking knot Buddhist emblems; there are six roundels on the skirt at front and back. At this time, too, when traditions were breaking down, to save money some men wore only the skirt part of the *chao pao* under the surcoat, which bore the badges of rank.

Mandarins of the fifth to seventh ranks wore a plain blue silk damask *chao pao* with gold brocade edging, while on

Chart 2.2 Second Style of Winter and Summer Court Robes

Rank	Colour	Dragon Placement
Emperor	yellow (other colours according to occasion)	four front-facing *long* on upper body and four on strip at waist; nine dragon roundels on upper part of skirt at front and back; one front-facing, two profile *long* at front and back on lower skirt; twelve imperial symbols
Heir apparent	apricot yellow	as above, but only seven roundels on skirt, and without twelve imperial symbols
Emperor's sons	golden yellow	four front-facing *long* on upper body; no roundels; four profile *long* on skirt at front and back
First- and second-degree princes	blue, brown, or other colours; golden yellow if bestowed	as above
Third- and fourth-degree princes and imperial dukes	as above	four front facing *mang* on upper body; four profile *mang* on lower part of skirt at front and back
Chinese dukes and other nobles; first- to fourth-rank civil and military officials; first-rank imperial guardsmen	blue-black	as above

the chest and back were profile *mang* squares. Members of the eighth and ninth ranks wore a plain *chao pao* with no squares. These robes belonging to lower-ranking officials are scarce as, like other court robes, it was usual for the men to be buried in them, and moreover they would not have been deemed sufficiently valuable by collectors to save.

Manchu Women's Court Robes

To maintain the 'pureness' of the Qing dynasty, emperors usually chose their wives from daughters of eminent Manchu families. For the sake of building political alliances, wives were sometimes chosen from important Mongol families, but not from among the Han Chinese. The Qing emperors continued the Ming system of polygamy in order to produce many offspring to ensure succession to the throne. The Kangxi Emperor, for example, sired thirty-five sons.

In addition to wives the emperors had many concubines, who were recruited every three years, aged between twelve and fifteen, to become Excellent Women (*xiu nu*). Taken from the important families of the Eight Banners, the aristocracy instituted by Nurhaci in the course of his unification of the Manchu clans, the girls' parents could be punished if they did not register their daughters' names for selection. If chosen, the girls would spend their time inside the Forbidden City until the age of twenty-five, when they were 'retired' and were free to leave if they wished. Another group of women in the palace were the daughters of the imperial bondservants, who took care of the personal duties of the emperor and his family. At a whim the emperor could also select a girl from this group to be his concubine or even his next wife.

Manchu women's status was determined by that of their husband or father, and women held no official role in the government. However, an empress dowager would act as regent during a ruler's minority, and she held even more power than the reigning emperor himself, due to the importance the Chinese attached to filial piety. For instance, the Empress Dowager Cixi (1835–1908) resumed supreme power over the Guangxu Emperor (r.1875–1908) after the reform movement failed in 1898.

There were some ceremonial events at which women from the imperial family would officiate in their own right, for example, at the Mulberry Leaves Ceremony. Here, the empress and women from her court would ritually pick the first and finest leaves from the sacred grove of mulberry trees to feed silkworms which would produce silk for state sacrificial dress. However, appearances in public of women from the lower classes were limited to occasions when they accompanied their husband. For Chinese women, the laws of 1652 stated that the principal wife of a Chinese nobleman or official should dress according to her husband's rank.

Little is known about early imperial women's robes until court and official dress was standardized in 1759 and their clothing, like that of the men, was divided into official and non-official categories, then subdivided according to the degree of formality (see Chart 2.3). Official formal dress worn at court comprised a full-length garment called a *chao pao*, with a square-cut lapel opening and projecting shoulder epaulets. This was worn with a large flaring *pi ling* collar shaped like the man's but with only two dragons, not five, and both front-facing. The epaulets were thought to be linked to a pre-Qing costume feature which originally protected the arms from bad weather. As with men's robes, the ground colour and arrangement of dragons indicated rank. There was an additional colour, a greenish yellow, *xiang se*, which was worn by daughters of the emperor and lower-ranking consorts.

Plate 5 shows Empress Xiaoxian, young wife of the Qianlong Emperor (r.1736–95), in full winter court dress: *chao pao*; a court vest (*chao gua*); a *zai shui*, a long pendant which denoted rank; three neckchains; a diadem around the forehead; a torque necklace; and a hat decorated with golden phoenixes and topped with a tall gold finial studded with pearls.

Chart 2.3 Women's Court Robes After 1759

Rank	Colour	Pattern
Empress, empress dowager, first-degree consorts	yellow	first winter style: front-facing *long* on chest, back, and shoulders; two profile *long* on skirt at front and back; edged in sable
	yellow	second winter style: design as emperor's second winter style, including *long*, edged in otter
	yellow	third winter style: as first winter style but split skirt at back, including *long*, edged in otter
	yellow	first summer style: as second winter style but edged with brocade
	yellow	second summer style: as third winter style but edged with brocade
Heir apparent's consort	apricot yellow	as above
Second- and third-degree consorts	golden yellow	as above
Fourth-degree consorts	*xiang se*	as above
Wives and daughters of first- and second-degree princes	brown, blue	third winter and second summer styles
Wives of other nobles and first- to third-rank officials	blue-black	as above, but with *mang*
Wives of fourth- to seventh-rank officials	blue-black	as above, but with two confronting profile *mang* on front and back

There were three kinds of women's *chao pao* for winter. The first was a long gown with front-facing and profile dragons displayed over it, with wave motifs at the hem but, until almost the end of the dynasty, without the *li shui*, the diagonal stripes of the five colours representing deep standing water. At the upper part of the long sleeves there were bands of coiling dragons inserted above the plain dark-coloured section which ended in horse-hoof cuffs. It was lined with white fur and edged with sable.

The second variation was very similar to the men's *chao pao*, being made in two sections with a pleated skirt attached to a jacket constructed as the first style. A four-lobed yoke pattern of dragons extended over the chest, back, and shoulders, while above the seam of the top and skirt was a band of dragons. A further band of dragons was placed on the lower part of the skirt.

The third style was like the first, but with a centre-back split in the skirt, and it was trimmed with otter fur. Figure 2.3 shows the front and back views as illustrated in the woodblock edition of the Regulations. Unlike the first two styles, this one could be worn by women other than those belonging to the imperial family.

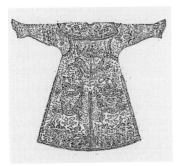 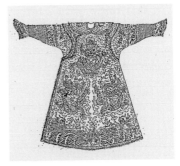

2.3 Back and front views of the third style of winter *chao pao*, as illustrated in the woodblock edition of the Regulations.

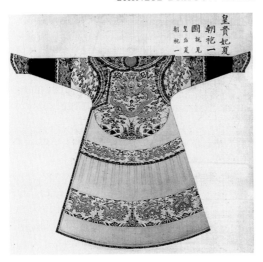

2.4 The first style of summer *chao pao* in yellow, belonging to an empress, empress dowager, or imperial concubine. A painting on silk from the Regulations.

Summer *chao pao* for women were of two types. The first was made of two sections like the second type of winter robe. Figure 2.4, painted on silk from the Regulations, shows the first summer style *chao pao* in yellow, belonging to an empress, empress dowager, or first-rank concubine. The second type of summer robe was identical to the third kind of winter robe, including the back split, except that it was made of gauze or satin and edged with brocade. Lower-ranking noblewomen and officials' wives wore the third style of winter *chao pao* or the second style of summer *chao pao*. A painting on silk from the Regulations (Plate 6) shows the second summer style *chao pao* and *pi ling* for a noblewoman. Despite the caption and text incorrectly inscribed as being for winter, it is clearly a summer robe. Many mistakes were made in the paintings and further editions were issued to correct them.

22

The Court Vest

Worn over the *chao pao* was a full-length sleeveless vest, opening down the centre, called a *chao gua*. An antecedent was a sleeveless vest of trapezoidal shape worn by the Ming empresses, although the deeply cut armholes and sloping shoulder seams appear to be derived from an animal skin construction of the Manchus.

There were three styles of *chao gua*, each made of dark blue silk edged with brocade. The first had three sections: the upper part, the part from the waist to the knee, and from the knee to the hem. Five horizontal bands of *long* or *mang* and lucky symbols were dispersed around the wearer according to rank. In Figure 2.5, Wan Rong, wife of Puyi, the deposed Xuantong Emperor (r.1909–11), is

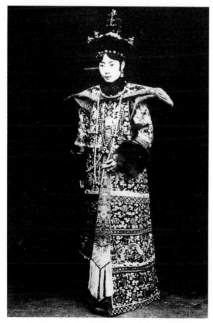

2.5 Wan Rong, wife of the Xuantong Emperor, wearing the first style *chao gua*, with *zai shui*, court hat, and *pi ling*, c.1922.

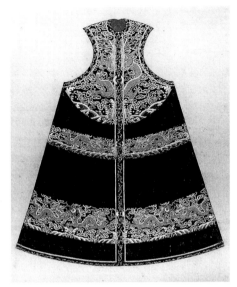

2.6 A painting on silk from the Regulations depicting the second style of *chao gua* for an imperial consort.

pictured at the time of their marriage in 1922 wearing the first style *chao gua*, with the *zai shui* pendant, court hat, three neckchains, and *pi ling*.

The second type, similar to the second style of *chao pao* with a sleeveless body part joined to a pleated skirt, is very rare and, like the first one, worn only by members of the imperial family. Figure 2.6 shows a painting on silk from the Regulations depicting this style of *chao gua* for an imperial consort. In Figure 2.7 an imperial princess is seen wearing the third style *chao gua* with profile ascending dragons and wave motifs, and later *li shui*. This style of robe could be worn by all ranks of women, including lower-ranking noblewomen and officials' wives.

A further style of *chao gua* not mentioned in the Regulations is a full-length sleeveless vest with a background colour of yellow, green, or white, and possibly other colours as well, with profile ascending dragons, edged with

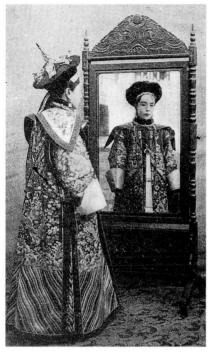

2.7 An imperial princess wearing the third style of *chao gua*, *c.*1900.

a velvet band and brass studs which suggest links with military uniforms. The deep fringe at the hem, which is lined behind, suggests a hybrid garment developed from the Chinese women's *xia pei* (ceremonial vest), which is reviewed in Chapter 6. These are quite scarce and may have been worn by Chinese noblewomen.

3

Qing Dragon Robes

DESPITE THE EARLY RELUCTANCE of the Manchus to wear the style of robes worn by the Ming court, by the reign of the Kangxi Emperor richly ornamented dragon robes were generally accepted for less formal court occasions and official business. Because they were worn by the lower ranks of officials, as well as members of the imperial family, they became the most common type of official robe to survive from the Qing dynasty. They were known as *ji fu* (festive dress), a term of great antiquity which suggested their considerable importance.

The Qing dragon robe was a full-length coat with sleeves and a curved overlapping right front like the top half of the *chao pao*, and based, it is thought, originally on animal skins, with two at the front and one at the back. Like the *chao pao*, it was worn belted, with purses containing daily necessities hanging from the girdle. To make it easier to ride in, the Manchus added slits at the centre seams of the front and back hems, in addition to those at the sides.

Robes with five-clawed dragons known as *long pao* continued to be the prerogative of the emperor, the heir apparent, and high-ranking princes, although the former could bestow this honour on lesser officials if he wished. *Mang pao*, four-clawed dragon robes, were worn by third-degree princes and below. Towards the end of the Qing dynasty, however, when many laws were disregarded, most robes were of the five-clawed variety and worn by all the ranks, as it was unthinkable to be seen wearing the four-clawed dragon. Colours for the *long pao* and *mang pao* were in accordance with those for the *chao pao*. The emperor wore

yellow, imperial princes shades of yellow, and mandarins blue or blue-black.

For the emperor and princes nine dragons were embroidered on the robes: at the chest, back, on each shoulder, two at the front hem, and two at the back hem (see Chart 3.1). The dragons on the upper part were usually front-facing, while those on the lower skirt part were in profile. Plate 7 shows a dragon robe in brown satin, edged with brocade, made for a prince. It is embroidered with nine gold couched dragons with five claws, Buddhist emblems in satin stitch, and clouds and bats on the indigo satin ribbed sleeves.

The symbolic ninth dragon was hidden on the inside flap of the robe. The number nine, and the fact that the ninth was hidden, had important symbolic connotations that drew on a knowledge of the relationship between tenant and landlord known as the *well-field* system. Eight farmers worked each of the eight fields around the perimeter, while all helped to farm the central ninth field. The eight fields protected the ninth by encircling it (Vollmer, 1980:22).

Noblemen and lower-ranking officials had eight dragons on their robes, lacking the ninth hidden one, but towards the end of the dynasty, when conventions were being flouted, most wore nine. Mandarins of the first, second, and third ranks could wear nine *mang* embroidered in the same arrangement as those on the emperor's and princes' robes: one each at front and back chest, one at each shoulder, and two at front and back hem, with the ninth dragon on the front inside flap. Fourth- to sixth-rank civil and military officials wore eight four-clawed dragons: minus the one on the under flap. Seen here in Plate 8 is an eight *long* robe for a fourth- to sixth-rank mandarin, who would have been awarded the privilege of having five claws by the emperor.

Chart 3.1 Regulations Governing Dragon Robes after 1759

Rank	Colour	Number of Dragons	Number of slits in skirt
Emperor	yellow; others according to occasion	nine *long*	four
Heir apparent	apricot yellow	nine *long*	four
Emperor's sons	golden yellow	nine *long*	four
First- and second-degree princes	blue, blue-black, or brown; golden yellow if conferred	nine *long*	four
Third- and fourth-degree princes, imperial dukes, and other nobles	as above	nine *mang*	four
Chinese nobles, first- to third-rank officials	blue, blue-black	nine *mang*	two (at front and back)
Fourth- to sixth-rank officials	as above	eight *mang*	two
Seventh- to ninth-rank officials*	as above	five *mang*	two

*In practice they did not wear dragon robes

Lower officials of the seventh to ninth ranks and unclassified officials were said to have been assigned to wear five *mang*, but this determination does not seem to have been put into practice, and low-ranking officials would seldom have needed to wear dragon robes. Those who had a low income could not have afforded one, and those who were rich would have used their wealth or influence to purchase a higher rank. At the end of the dynasty, the lowest officials could have taken to wearing an eight- or nine-dragon robe if the occasion warranted it.

Evolution of Pattern

Until the laws of 1759, the court was free to decide for itself the pattern of these less formal robes, as long as they were cut in Manchu style and obeyed the laws regarding colour and number of claws. The dispersion of dragons was not regulated and early robes continued the Ming tradition of the large curling dragons over chest and back. A rare early Qing robe (Fig. 3.1) has two full-length profile dragons embroidered with satin stitch and couched gold thread on chest and back, which are surrounded with sixteen small insignificant ones.

A further development is seen in Plate 9 with a *yue bai* ('moon white') brocade dragon robe, made in the early eighteenth century, to be worn by a nobleman for a ceremony at the Altar of the Moon during the autumn equinox. The dragons on chest and back are front-facing and reduced in size, while the ones on skirt hem and shoulders have become larger. By the mid-eighteenth century, the size of the upper dragons had become smaller and the lower dragons bigger, until on most robes they were the same size.

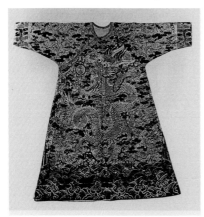

3.1 An early type of dragon robe, the two large profile dragons embroidered with satin stitch and couched gold thread, *c.*1675.

29

Dispersed amongst these emblems were cloud patterns, and at the hem of the dragon robes were waves, stylized mountains, and *li shui*. In the early part of the dynasty, the mountains were towering and bold, but later they became shorter and unnatural, while the *li shui* became much longer and the waves more dominant. By the end of the nineteenth century the background of the robes was cluttered with a multitude of symbols and lucky charms, especially the Eight Buddhist Emblems and the Eight Daoist Emblems.

Surcoats with Dragon Roundels

Another early style of dragon robe having circular roundels to depict rank for the imperial family was a continuation of the Ming tradition. Higher ranks had five-clawed dragons shown front-facing, while *long* or *mang* were in profile for lower ranks. A portrait of the first Qing emperor Shunzhi shows him wearing a yellow robe with eight dragon roundels: at front and back, on each shoulder, plus two each side on the skirt. The original arrangement existing in the Ming, whereby the roundels were in the centre of the skirt, would have been impractical when the skirt of the robe was slit at the centre front and back seam.

This circular embroidered form was extended to the *gun fu*, the imperial surcoat, which became official court dress after 1759, and four roundels with dragons were placed at chest, back, and shoulders. The Qianlong Emperor, who loved pomp and pageantry, added the first two of the twelve imperial symbols, the sun and moon, to the shoulder roundels on his *gun fu*, while the roundels at chest and back had the *shou* symbol for longevity (see Chart 3.2). Beginning in the middle of the nineteenth century, the constellation

Chart 3.2 Imperial Rank Insignia

Rank	Insignia	Colour of surcoat
Emperor	four roundels with front-facing *long*; yellow sun on left shoulder, moon on right; *shou* character on front and back roundels	yellow, or others if desired
Emperor's sons	four roundels showing front-facing *long*	apricot yellow
First-rank princes	four roundels showing front-facing *long* on chest and back with profile dragons on shoulders	golden yellow
Second-rank princes	four roundels showing profile *long*	golden yellow
Third-rank princes	two roundels showing front-facing *mang* at chest and back	blue
Fourth-rank princes	two roundels showing profile *mang*	blue
Imperial dukes	two square badges showing front-facing *mang*	blue
Other non-imperial nobles	as above	blue

of three stars was added to the front medallion, and the mountain to the back one.

Other insignia badges were worn by lower-ranking princes and noblemen on the chest and back of the surcoat. These were square and not circular and depicted the *long* or *mang* (Fig. 3.2).

Women's Dragon Robes

For semi-formal official dress, or festive dress, women within the imperial family wore the *long pao*, a robe embroidered with five-clawed dragons, side-fastening, with long sleeves ending in horse-hoof cuffs. Unlike those worn by

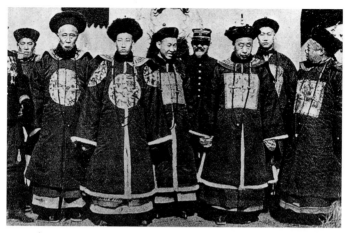

3.2 The Guangxu Emperor (fourth from left) and members of the imperial family wearing surcoats bearing dragon roundels (lower-ranking members wear square insignia badges), *c.*1900.

men, the women's dragon robes had no splits at centre back and front hem. Additional bands of dragons at the seams linking the upper and lower sleeves were, in theory, restricted to the empress and highest-ranking princesses, although in practice they were adopted by all Manchu women.

Again there were three types of dragon robe. The first, worn by all women of the court, had dragons dispersed over it, the colour and number of dragons indicating rank, with a wave border at the hem (see Chart 3.3). Later in the nineteenth century the sleeves of these robes had degenerated, ending in wide horse-hoof cuffs. Plate 10 shows an imperial consort's summer *long pao* in counted stitch on silk gauze with the wider sleeves, and the twelve imperial symbols, lined in yellow silk. Noblewomen and officials' wives wore the *mang pao*, the four-clawed dragon robes, in this style.

Chart 3.3 First Style of Women's Dragon Robes

Rank	Colour	Pattern
Empress, empress dowager, first-rank consorts	yellow	nine *long*
Heir apparent's consort	apricot yellow	nine *long*
Second- and third-rank consorts	golden yellow	nine *long*
Other imperial consorts	*xiang se*	nine *long*
Wives of first- and second-rank princes	blue, brown*	nine *long*
Wives of other nobles and first- to third-rank officials	blue, blue-black	nine *mang*
Wives of fourth- to sixth-rank officials	blue, blue-black	eight *mang*
Wives of seventh- to ninth-rank officials	blue, blue-black	five *mang*

*golden yellow if conferred on her husband

The second style of *long pao*, with eight roundels of dragons and a wave-pattern hem, was officially restricted for wear by the empresses. Figure 3.3 shows the second-style *long pao* with eight dragon roundels embroidered on golden brown brocade. The robe, bearing the Hundred Cranes, symbols of longevity, is from the tomb of Prince Guo Jinwang (d.1738) and his consorts. However, some robes made later in the dynasty, with the degenerated sleeves and wide horse-hoof cuffs popular by this time, have this roundel pattern on them and were worn by noble-women. The third type was also for wear only by emp-resses and had the eight roundels with no wave pattern. This style is seen here in Figure 3.4, showing a *long pao* with no *li shui*, in yellow silk with eight dragon roundels made from the woven silk tapestry technique called *kesi*.

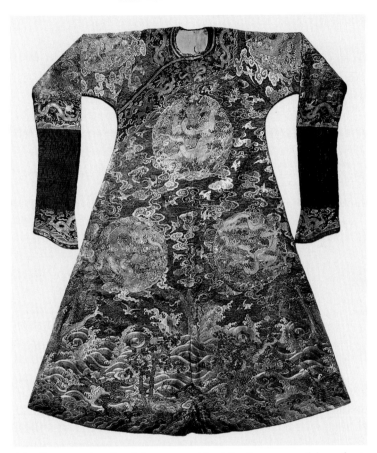

3.3 The second style of *long pao* with eight dragon roundels embroidered on golden brown brocade. The robe, bearing the 'hundred cranes', symbols of longevity, is from the tomb of Prince Guo Jinwang and his consorts. Eighteenth century; 138 cm (l).

The Dragon Coat

When empresses and high-ranking consorts and noblewomen appeared in public, they were required to wear the *long gua* (dragon coat) over the *long pao*. This garment was a full-length, centre-opening, wide-sleeved surcoat in blue-black satin or gauze with dragon roundels arranged over it. There were two types: the first had the eight roundels of dragons displayed on chest, back, shoulders, and front and back hem of the coat and the *li shui* pattern, like that on the second style of *long pao*. A robe from the late nineteenth century (Plate 11) is embroidered with satin stitch and couched gold thread onto dark blue satin and lined with matching pelts of fur. In Figure 3.5 the Guangxu Emperor's consort, Dowager Duan Kang, is seen wearing this first-style *long gua* and matching *long pao* with the wide cuffs of the dragon robe turned back over the surcoat. The second style had the eight roundels without the wave border, similar to the third style of *long pao*.

Imperial princesses were expected to wear the upper four or two roundels on a plain surcoat (*pu fu*), to match their husbands', although it seems they preferred to wear the *long gua* with *li shui*. Lower-ranking noblewomen should wear the surcoat with eight roundels of flower motifs surrounding the *shou* character and no *li shui*. Wives of officials should also follow this rule, but in practice they wore a *pu fu* which bore the badge of rank like that of their husbands.

Chinese women, according to the laws of 1652, wore a surcoat with rank badge over a dragon jacket and skirt.

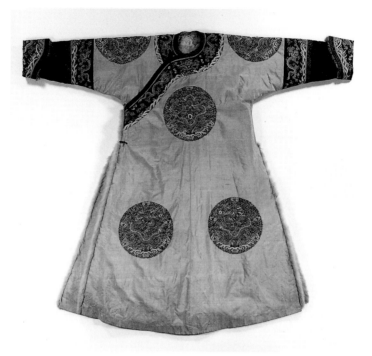

3.4 The third style of *long pao* with no *li shui* in yellow silk with eight dragon roundels in *kesi*. 172 cm (l).

Children's Dragon Robes

Offspring of the emperor and members of the Manchu court wore smaller versions of dragon, and court, robes. A rare example of a young prince's dragon robe is shown in Plate 12. Dated to about 1800, it is embroidered with the twelve imperial symbols onto yellow satin. Sons who still lived at home or who had not taken public office, and daughters who had not yet married, could wear the dress

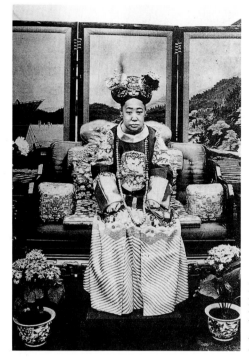

3.5 The Guangxu Emperor's consort, Dowager Duan Kang, wearing the first style of *long gua* and *long pao*, *c.*1913.

of their father, except for his actual insignia of hat jewel, girdle plaques, and rank badge. Despite this limitation, children's rank badges surface from time to time, further demonstrating that traditional laws were disregarded towards the end of the dynasty.

4

Methods of Construction

FROM THE BEGINNING OF THEIR USE, at the time of the Tang and Song dynasties, silk, in different weights and weaves, was used for making dragon robes. Silk had been produced in China for several millennia before this time, remnants of silk fabrics being found with bronzes dating back to the Shang dynasty (c.1500–c.1050 BC). In Chinese folklore the discovery of silk fibre has been attributed to Lei Zu, wife of Huangdi, the legendary Yellow Emperor. However, recent archaeological evidence, including the discovery of neolithic stone ornaments in the shape of silkworms, indicates that silk was first produced in China even before that time, six to seven thousand years ago.

By the time of the Zhou dynasty (c.1050–221 BC) imperial workshops were producing silk fabrics for the court, and these factories were supervised by imperial officials. As the wearing of silk spread outside the court circle the material began to be traded, becoming a very valuable commodity. By the second century BC a route had been opened from Chang'an (present day Xian) in Shaanxi province, through Xinjiang in north-west China, to Syria 11,000 kilometres away. This route became known as the Silk Road, and it was by this means that China exported silk and other goods to the West. The secret of silk production stayed with the Chinese until around the middle of the fifth century AD when, again according to legend, a Chinese princess carried silkworm eggs hidden inside her head-dress when she went to marry the King of Khotan.

Weaves

Traditionally, the finest robes have been made by a weaving technique introduced by a minority group, the Uygurs, during the Tang dynasty. This was called *ge* silk weaving, or more commonly *kesi*, literally 'cut silk'. Each colour is doubled back on itself, without any floating threads behind, forming small gaps between each colour and thus making it quite fragile for frequent use.

A faster method of weaving, and thus a more widely available product, was silk brocade. Plate 13 shows how the design of the dragons was incorporated into the weave on the upper part of an uncut brocade court robe dating from the late seventeenth century. The silk, and the metallic, threads are carried across the back of the design, so the amount of silk used is high. The Manchu invasion of the south was not resolved for many years, and as a result the production of silk, particularly at factories such as the one at Yangzhou, was disrupted. During this time of silk shortage, availability of robes using the brocade and *kesi* techniques was limited, making a comeback for wider use only in the late nineteenth and early twentieth centuries. Neither matched their earlier splendour: the *kesi* in particular was coarser, with much of the detail painted on in ink.

Embroidery

The main fabric used for the robes was satin, as the high sheen appealed to the Manchus, and by the laws of 1652 it became the prescribed choice for all official robes. Later, in the eighteenth century, silk gauze, which was cool and

airy, was favoured for summer robes. Because these plain fabrics were used, designs on the robes were embroidered.

Gold or silver threads, made by wrapping narrow strips of gold or silver foil around a silk core, were often used to depict the dragons. This was done by couching, a way of anchoring these metallic threads (or thin strips of material or paper), which could not be sewn directly as they might break or split the silk cloth. The threads or strips were laid in rows on the surface of the cloth and a toning silk thread was employed to hold them in position.

Satin stitch, which dates back to the Shang dynasty, became an important part of an embroiderer's repertoire in the Qing dynasty. The floss silk filaments must all lie the same way and the stitches must be very flat and even to give the characteristic satin smooth appearance. Long-and-short stitch, used to give gradations of colour and shade, was another type of satin stitch, made by making the first row of stitches alternately long and short; thereafter all the rows would have stitches the same length.

Seed stitch, also called Peking knot, is similar to French knot. It is known as *da zi* in Chinese, meaning 'making seeds', due to the smallness and evenness of the stitch. It was also called forbidden stitch or blind stitch by some Westerners, as it was said to ruin the eyesight of the embroiderers. There is no legal evidence of such a ban, and many other stitches are equally fine. The stitch was used to give a soft texture, to fill in small areas, or to define details. The stitches had to be absolutely even, next to each other, and the rows completely straight. Counted stitch, also called tent stitch, petit point, or half-cross stitch, was a short, straight slanted stitch, used on the open weave cloth of silk gauze.

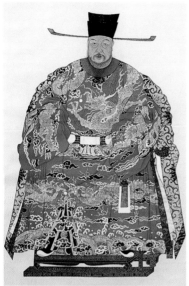

1. A portrait of Wang Ao (1450–1524), a high-ranking official, wearing a four-clawed dragon presentation robe.

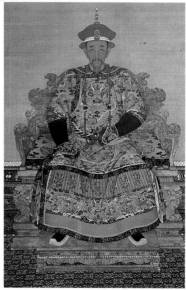

2. A portrait of the Kangxi Emperor wearing full summer court attire.

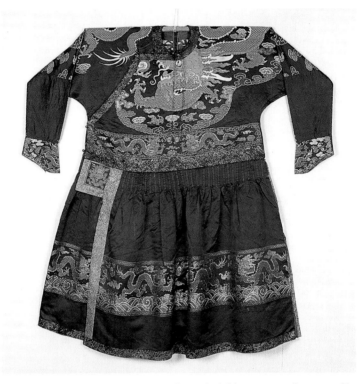

3. An early Qing summer court robe in dark blue satin with two profile *mang* dragons on chest and back in brocade, and four on the front and back skirt. 133 cm (l) x 206 cm (w).

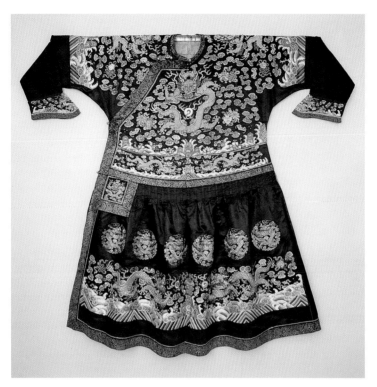

4. A court robe belonging to an official, in dark blue satin, edged brocade, and with gold couched dragons, satin-stitch clouds, Peking knot Buddhist emblems, and six roundels on skirt at front and back. Mid-nineteenth century. 138 cm (l).

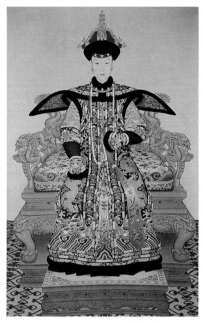

5. Empress Xiaoxian, young wife of the Qianlong Emperor, in full winter court dress: *chao pao, chao gua, zai shui*, hat, diadem, torque necklace, and three neckchains.

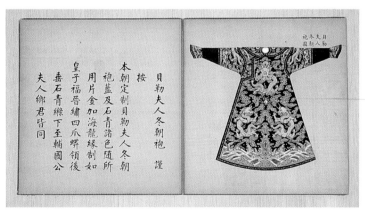

夫人鄉君皆同
垂石青縧下至輔國公
皇子福晉繡四爪蟒領後
用片金加海龍緣制如
袍藍及石青諸色隨所
本朝定制貝勒夫人冬朝
按
貝勒夫人冬朝袍　謹

袍冬夫貝
圖朝人勒

6. The second style of summer *chao pao* and *pi ling* for a noblewoman; a painting on silk from the Regulations.

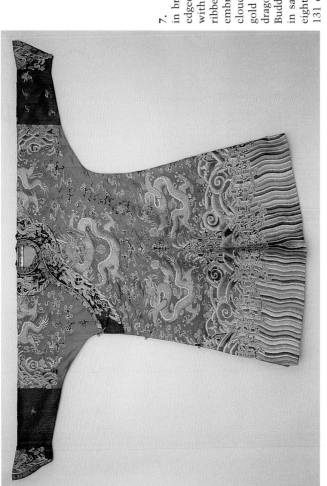

7. A dragon robe in brown satin edged in brocade, with indigo satin-ribbed sleeves, embroidered with clouds and bats, gold couched dragons, and Buddhist emblems in satin stitch. Late eighteenth century; 131 cm (l).

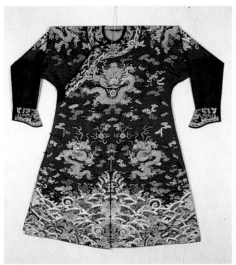

8. An eight *long* robe for a mandarin of the fourth-to-sixth rank, in dark blue satin embroidered with gold couched dragons, bats, peonies, and Buddhist emblems in Peking knot, satin stitch clouds, and chain stitch *li shui*, and with slits at back and front hem only and ribbed silk sleeves. Qianlong period; 135 cm (l) x 210 cm (w).

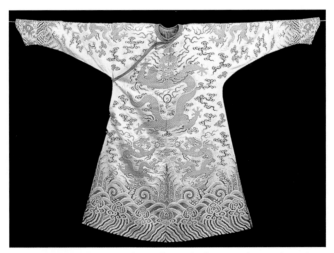

9. A *yue bai* ('moon white') brocade dragon robe made to be worn by a nobleman for a ceremony at the Altar of the Moon during the autumn equinox. Early eighteenth century; 138 cm (l) x 206 cm (w).

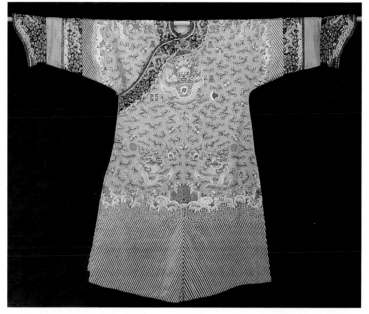

10. A *long pao* of the first style with the twelve imperial symbols, embroidered with counted stitch on gauze with gold couched dragons, and belonging to an imperial consort, *c.*1875. 144 cm (l) x 188 cm (w).

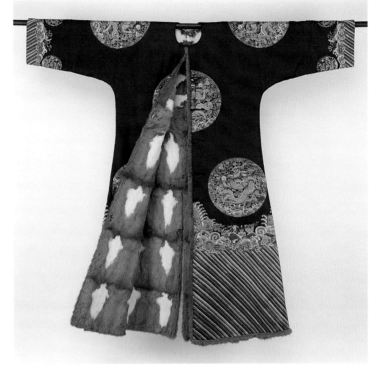

11. A fur-lined surcoat made of dark blue satin with dragon roundels embroidered in satin stitch and couched gold thread. Late nineteenth century; 141 cm (l) x 150 cm (w).

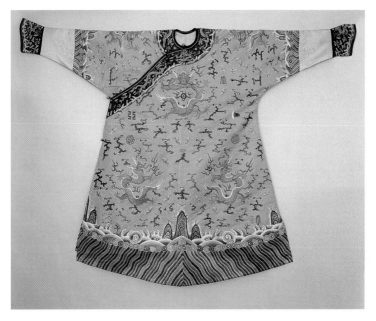

12. A dragon robe for a young prince, with the twelve imperial symbols, *c.*1800. 108 cm (l) x 150 cm (w).

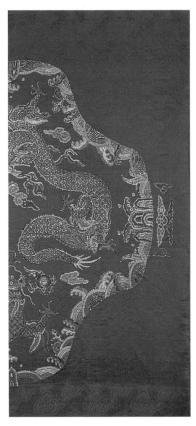

13. Part of an uncut brocade court robe with profile *mang* on chest and back. Seventeenth century; 71 cm (w).

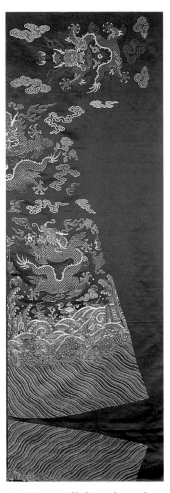

14. Uncut silk brocade yardage for a dragon robe, *c.*1800.

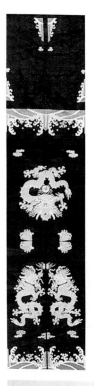

15. An uncut length of brocade for a Manchu lady's court vest. Kangxi period; 280 cm (l) x 66 cm (w).

16. The back view of an early brocade court robe, shown in full in Plate 3, showing the fierce dragon.

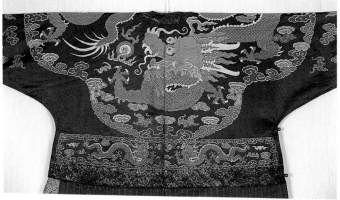

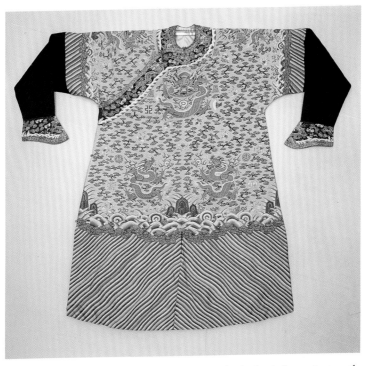

17. The emperor's twelve symbol dragon robe in *kesi*. Late nineteenth century; 142 cm (l) x 240 cm (w).

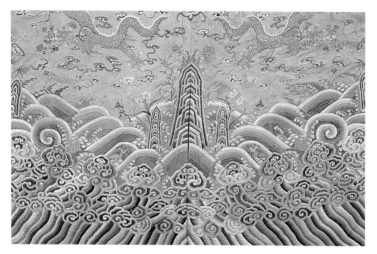

18. The hem of the yellow embroidered dragon robe shown in full on the cover, showing wavy *li shui* and the halberd, a rebus for 'rise up three grades'. Early eighteenth century.

19. Detail of an imperial princess's robe in *kesi* showing a bat holding a coins. Nineteenth century.

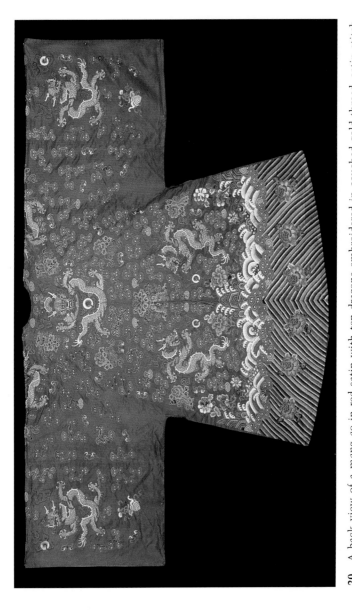

20. A back view of a *mang ao* in red satin with ten dragons embroidered in couched gold thread, satin stitch clouds and *li shui*, Buddhist emblems, and peonies embroidered in Peking knot. Nineteenth century.

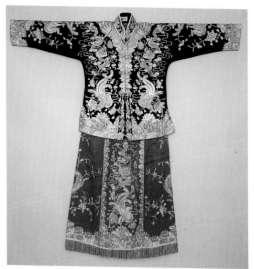

21. A wedding *hong gua*, with a black satin jacket and red satin skirt heavily couched with gold and silver thread in a dragon and phoenix design. Mid-twentieth century; jacket, 64 cm (l), skirt, 94 cm (l).

22. A *xia pei* in dark blue silk embroidered with gold couched dragons, satin stitch clouds and bats, Peking knot birds of the first, third, and fourth ranks on the front, fifth, seventh, and ninth on the back, and a fourth-rank civil badge of gold couched thread. Nineteenth century; including fringe, 110 cm (l).

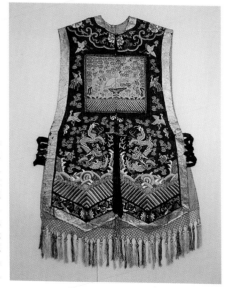

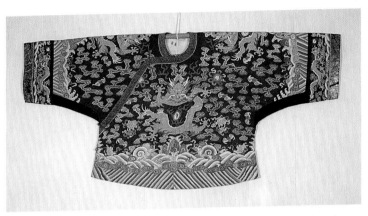

23. A Manchu lady's dragon jacket in *kesi* with four five-claw front-facing dragons surrounded by Buddhist emblems, *c.*1825–50. 67 cm (l) x 145 cm (w).

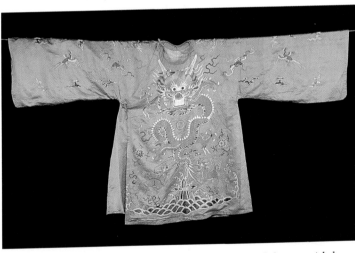

24. An image robe in yellowish green satin lined with hemp, with large central front-facing dragons rising above two *qilin*, all embroidered in couched gold thread. Dated to 1741; 130 cm (l) x 262 cm (w).

Dyes

There is little written information concerning Chinese methods of dyeing. There were no formal recipes, and details such as the proportion of the ingredients, the length of time it took to dye the silk fibre, and the number of times cloth was immersed to achieve the desired colour were all jealously guarded secrets known only to individual dyers.

Evidence shows that as far back as the Warring States period (475–221 BC) the Chinese were using dyes made from plants, leaves, or bark. In the Han dynasty (206 BC–AD 220) there were more than twenty hues in existence, and by the Qing this had grown to several hundred. Some plants gave a fast dye (that is, the colour would not wash out), but many were not fast and required a mordant, a substance used to fix the colour into the fabric. The application of the mordant also better enabled the fabric to take the colour successfully, thus enhancing it. Mordanting is done before dyeing, the wet yarn or fabric being immersed in the solution for the required length of time. Different mordants could produce different shades from the same plant dyes.

The main mordants used in China were alum or potash, obtained by boiling hemp or rice straw; iron, achieved by boiling iron shavings, nails, and the like; and slaked lime, obtained from sea shells. Chrome and tin were also used as mordants, as was the tannic acid present in some dye plants such as sumac and gall nuts.

Blue, being the dynastic colour of the Qing, was the most widely used colour for dragon and court robes. The dye came from the indigo plant, *Indigofera tinctoria*. Yellow, for the emperor's robes, was obtained from the safflower plant, *Carthamus tinctorius*, and the pagoda tree, *Sophora japonica*, as well as the powdered roots of the turmeric plant, *Curcuma longa*, with a mordant of potash.

Chemical dyes were developed in England in 1856 and introduced into China in the 1870s. This development signalled the demise of natural dyes and the rise in popularity of synthetic aniline dyes, which could then be obtained relatively easily and inexpensively. Colours such as a garish purple, lime green, shocking pink, and a bright turquoise made their appearance on robes, as the newness of the tints were attractive to many after the earlier, more mellow, though more limited, dyes from plants. The use of these colours helps to date the robe, although plant dyes continued to be used into the twentieth century by some embroidery studios.

Layout and Cut of the Robes

A court robe with the dragon design incorporated into the brocade weave was made from two lengths of silk, one forming the left side, the other the right side. The bands of the skirt and the cloud collar were in a continuous length joined down the centre seam. The skirt part was cut from the upper part, which was then scooped out under the arms and the skirt pleated to fit the narrowed-down upper portion. Notice how in Plate 13 the design of the silk in the plain area changes to indicate the cutting line for the waist.

Figure 4.1 shows the layout for the brocade court robe shown in Plate 3, with the shaded areas indicating where the design occurs. The skirt would be cut as indicated, then pleated onto the waistband, which had another band of dragons. Sleeves were added to where the cloud collar design finished, and ended in horse-hoof cuffs which were made from brocade but with a smaller design of dragons. The edges round the neck opening, skirt hem, waist, and *ren* were all trimmed with 3 centimetre wide gold brocade.

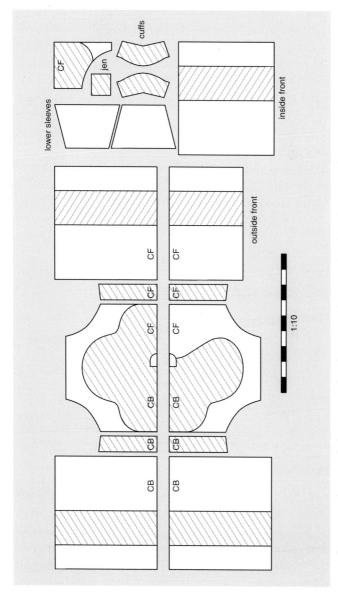

4.1 The cutting layout of the court robe shown in Plate 3. The shaded areas indicate the brocade design.

The fabric for a dragon robe was woven in a continuous-length cut and joined down the centre with the fold at the shoulders, but with extra fabric for the outside front flap. Plate 14 shows a length of brocade for a dragon robe made in about 1800 with five-clawed dragons, all the same size, surrounded by bats, flowers, and the Buddhist emblems. The silk is 76 centimetres wide and a red knot marks the mid-shoulder points; the shoulder-to-hem measurement of the finished robe would be 147 centimetres.

Figure 4.2 shows the cutting layout of a dragon robe, in this case the one illustrated in Plate 8. The outer front flap would be attached to the centre front seam of the left-hand

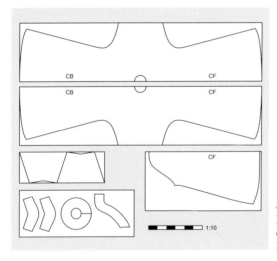

4.2 The cutting layout of the dragon robe shown in Plate 8.

portion of the robe. Lower sleeves were cut from different silk fabric, which was often ribbed, and lined with stiffened silk gauze. The neckband and cuffs were made of a different colour and material again, backed with stiffened silk gauze and lined with pale blue figured silk. The design of the robe was repeated in miniature on the neckband and

44

cuffs, and the edges were finished with a narrow band of gold brocade. There are many instances of earlier robes having replacement neckbands and cuffs or replacement bands of brocade, as these tended to wear out more quickly than the robe itself. In particular, the black dye used for the ground cloth of the neckband and cuffs in the latter part of the Qing dynasty often caused the silk fabric to shatter and so was replaced.

Plate 15 shows a rare uncut court vest for a Manchu lady. The length of brocade has the design of two profile dragons down the front, each side of the centre opening, with one front-facing dragon at the back. At the hem is low *li shui* and towering mountains which, together with the plain uncluttered background suggest it was made during the reign of the Kangxi Emperor. The trapezoid shape of the garment would be achieved by cutting the area immediately under the *li shui* at the back and adding the triangular pieces to the side hems.

When embroidering an important robe the main design would be drawn onto heavy rice paper, with one half drawn in black ink and the colours filled in as appropriate, and the other half as drawn areas. Figure 4.3 shows a cartoon for a robe displaying the twelve imperial symbols, painted and stamped on silk. The dimensions of the robe would be 143 centimetres wide, measured from the sleeve edges, and 130 centimetres long, and it was intended either for the young Guangxu or Xuantong emperor. The panels were joined down the centre seam, then the designs were transferred to the fabric either by tracing them with a fine line in black ink or by pricking the cartoon and pouncing a white powder, which was then fixed onto the cloth with an adhesive. The marked silk was stretched over a rectangular frame and several embroiderers would sit around it to work on the design. The important centre motifs, such

4.3 Cartoon for a robe with the twelve imperial symbols, painted and stamped on silk. Late nineteenth century. 285 cm (l) x 180 cm (w).

as the main dragons, were worked over the centre seam, thus covering it. Roller frames were not used for large and important pieces of embroidery, as the areas rolled up would be flattened and spoilt.

With a less important robe, the outline would be drawn, but the colours would only be noted on the appropriate areas and not coloured in. Figure 4.4 shows a design for a dragon robe drawn on two pieces of rice paper in ink. The two pieces for the robe part measure 63 centimetres wide by 113 centimetres long. One piece has the drawing for the skirt part up to the base of the front-facing dragon at chest and back. The upper piece shows chest and back dragons, shoulder front-facing dragons, and *li shui* at the sleeve edges, with a line drawn across to indicate the shoulder fold. The overall finished measurement of the robe would have been 154 centimetres long and 61 centimetres from

4.4 An ink drawing on two pieces of paper for the embroidery design of a dragon robe. Late nineteenth century.

centre front/back to sleeve edge. The cuff part was drawn on paper 30 centimetres high and 52 centimetres wide. (Only the neck band is missing.) Not included are the lower sleeves parts, which would have been plain and not embroidered. The design of this late nineteenth century robe has five-clawed dragons surrounded by clouds, bats, coins, the *wan* emblem for long life, and some of the Eight Buddhist Emblems including the pair of fishes.

Most robes were lined in lightweight figured silk in either yellow or pale blue. Twice a year, in the spring and autumn, orders would be given by the Board of Rites in the capital as to the day on which the type of lining should be changed to fur-lined, wadded with silk or cotton waste for the cold months, and back to silk for the warmer weather.

Moulded brass or copper spherical buttons, either smooth and plain or with surface decoration, were attached with

silk loops. All robes fastened to the right with buttons usually in odd numbers, especially five, with one at the neck, one at the curved point of the neckband, one at the underarm, and two lower down the right-side seam.

The Imperial Silkworks

When new dragon robes were required by the court, the request would be sent by the eunuchs to the Imperial Weaving and Dyeing Office, a department within the Office of the Imperial Household (*Neiwufu*). The Imperial Weaving and Dyeing Office had been set up during the reign of the Kangxi Emperor and supplied the patterns for the robes, as well as the dyes. Some weaving was done there on the site, but the majority was carried out at factories in Suzhou, Hangzhou, and Nanjing. The Imperial Silkworks were established in these three southern cities during the Ming dynasty, although silk-weaving had been produced there already for many centuries. The silkworks were supervised by the Office of the Imperial Household from 1652 until they went out of service in 1894.

The great trade of Soochow [Suzhou] is silk; and in the hongs are found a hundred varieties of satin and two hundred of silks and gauzes.... In the Nanking [Nanjing] and Soochow Guilds [in Suzhou alone] there are 7,000 looms in constant operation. In and around the city 100,000 women are employed in embroidering mandarins' robes, ladies' dresses and stage actors' apparel, and twice a year the Imperial tailor sends on as tribute a thousand trunks of embroidered robes for the Emperor's household (Wade, 1895: 98).

From Nanjing came all the satin for the imperial court, as well as tribute satin, the first and finest bolt of the season.

Regulations governed how the factories should proceed. Bolts of silk gauze or satin for the imperial dragon robes and other robes with five-clawed dragon medallions were to be two Chinese feet wide (about 70 cm), and either twenty or forty Chinese feet long (700 cm or 1,400 cm), while other fabrics, including satin and gauze for robes with four-clawed dragons, must be 70 centimetres wide and 42 feet (1,470 cm) long. By the laws of 1652 the Imperial Silkworks

were ordered to send annually to Peking [Beijing] two robes of silk tapestry (k'o-ssu)[kesi] with five-clawed dragons, one of yellow with blue collar and cuffs, and one of blue with dark blue collar and cuffs. These were to be sent alternately in the Spring and Fall of each year to the Palace Storehouse in Peking. At the same time, other weaving in k'o-ssu was forbidden (Cammann, 1952:117).

Once the Imperial Silkworks had fulfilled their annual quota of fabrics for the imperial court, they were then free to take on other orders from wealthy families.

When the robes were completed, they were sent to the capital. Figure 4.5 shows a late nineteenth century delivery chop for a consignment of dragon robes made in Nanjing and to be dispatched to Beijing. It was issued to a subordinate by the chief superintendant of the Imperial Silk Manufactury at Nanjing, who was concurrently a senior customs commissioner in Jiangxi province to the south. The woodblock chop gave authorization for the transportation of sixty-one chests of dragon robes and other items from the department to the Office of the Imperial Household at Beijing, and their smooth passage through the several customs inspection posts en route.

The chop, which is printed in blue ink on paper, is marked with red ticks as each hurdle was safely passed. Initially,

4.5 Woodblock delivery chop for a consignment of dragon robes. 43 cm (h) x 39 cm (w).

there were two identical printouts, folded in half and stamped in red across the fold. When the order was complete, the chop was given along with the consignment of robes and handed over to the keeper of the other chop. It is probably significant that the head of the Imperial Silk Manufactury was also concurrently gazetted a high customs official, as the second part of the document lays stress on getting the goods safely and without delay past the customs posts. The date is interesting, too: the 19th year of the Guangxu reign, 12th month, 30th day, equivalent to 5 February 1894, for this would have been the eve of the Lunar New Year, a time when traditionally all offices were sealed for about one month and no official business could be carried out. Perhaps the robes were urgently required for the coming spring season and regulations were waived as more sartorial considerations took precedence?

5

Symbolism on the Robes

MORE THAN JUST a splendid and colourful covering, the dragon robe had a clear cosmological significance. The robe itself forms

a schematic diagram of the universe.... The lower border of diagonal bands and rounded billows represents water; at the four axes of the coat, the cardinal points, rise prism-shaped rocks symbolising the earth mountain. Above is the cloud-filled firmament against which dragons, the symbols of imperial authority, coil and twist. The symbolism is complete only when the coat is worn. The human body becomes the world axis; the neck opening, the gate of heaven or apex of the universe, separates the material world of the coat from the realm of the spiritual represented by the wearer's head (Vollmer, 1977: 50).

Usually portrayed grasping the flaming pearl, a Buddhist emblem representing enlightenment, the dragon symbolizes the emperor's search for divine truth or the wisdom of heaven to the benefit of the empire.

Dragons

The concept of *yin* and *yang*, complementary positive and negative forces in nature, was an important influence on the design of dragon robes. This system of coexisting opposites was seen to maintain a balance in the universe—an excess of either element was dangerous. The dragon, and by extension, the emperor, was the embodiment of *yang*, symbolizing power and masculinity. Its eighty-one scales were a product of nine times nine, the most powerful *yang*

number. The five claws on the emperor's dragon conveyed another *yang* number, while lesser mortals had four claws, a *yin* number.

The large dragons, which at the beginning of the Qing dynasty had wound sinuously around the neck of the robe or stretched full-length down the front, gradually diminished. The smaller ones near the hem grew larger until by the mid-eighteenth century all were the same size. At the same time the ferocious dragon's face, and its spiky eyebrows, staring eyes, and open jaw, as seen in the early dragon robe shown in Figure 3.1 and in a detail of a court robe (Plate 16), became much less fierce and was by end of the nineteenth century a poor impersonation of its former self.

Li Shui

Yin influences are needed to counterbalance *yang* forces, and so at the hem of a robe appears the border of diagonal bands called *li shui* ('upright water'), representing standing water, a *yin* element. On early robes the *li shui* is undulating and natural-looking, with crashing waves, the colours of the waves picked out in distinct bands. They gradually became choppy, although still aligned in alternating directions, but grew straighter, until by the nineteenth century the diagonal lines had become upright. By this time they were pointing towards the centre and became much longer until they took up almost a third of the length of the robe, while at the same time the waves appeared flatter and less turbulent.

The length of *li shui* on robes increased noticeably in the Daoguang period (1821–50), possibly beginning as an easy way of lengthening the robes to accommodate the extra height of the Daoguang Emperor and then passing

into common usage. Another possibility, however, relates the change to the *yin* element. In the early years of the dynasty, when strong emperors ruled, the empress, who was *yin*, was seldom present. In the latter half of the nineteenth century, when the Empress Dowager Cixi assumed power over her adopted nephew, the lines of the standing water grew even longer as her power increased.

Interspersed between the *li shui* were mountains, at centre front and back and at the sides of the hem, which were a *yang* element and a symbol of earth, steadfastness, and longevity. Towering and pointed in the early years, they gave way to a flatter, more geometric design by the end of the Qing dynasty.

The Twelve Symbols of Imperial Authority

The twelve imperial symbols were the most important of all the elements displayed in the background of court and dragon robes, and their use was confined to the emperor. The full group of twelve symbols had first appeared on sacrificial robes during the Zhou dynasty, and then again were seen during the Han dynasty. Placed on the outer jacket and skirt of these early robes, when worn they assumed cosmic significance, with the emperor representing the Ruler of the Universe. Woven into the jacket were six symbols: the sun and moon disc on the left and right shoulders, the constellation of seven stars of the Big Dipper placed above a mountain on the back, and dragons and pheasants on each sleeve. Embroidered on the skirt were a further six symbols, each appearing in a pair and together forming four columns: the sacrificial cup, water weed, grains of millet, flames, sacrificial axe, and *fu* symbol, together representing the forces of good and evil.

The Twelve Symbols of Imperial Authority were used for the first time on informal robes, that is, other than those for sacrificial ceremonies, in the reign of the Zhengtong Emperor (r.1436–49). Avoided at first by the Manchus as being associated with the Ming and preceding Chinese dynasties, the twelve imperial symbols were reintroduced by the Qianlong Emperor in 1759 and appeared first on court robes and were then later applied as well to less formal dragon robes.

Figure 5.1 illustrates the full Twelve Symbols of Imperial Authority, from top left: the sun disc with three-legged rooster, the constellation of stars, the moon disc with hare, the dragon, the mountain, the water weed, the grains of millet, the 'flowery bird' or pheasant, the fire, the sacrificial axe, the sacrificial cups, and the *fu* symbol, the Symbol of Discrimination.

The twelve symbols are also arranged over the body of a late nineteenth century emperor's dragon robe made in *kesi* (Plate 17). The first three symbols of sun disc, moon disc, and the constellation of stars, which had been reduced to three from seven, could only be worn by the emperor. Although the use of the twelve symbols was restricted to the emperor he could, if he wished, confer the right to use them on others, and some women's robes bearing all twelve, and fewer, symbols are extant, having belonged to an empress or imperial consort. For instance, several of the empresses in the nineteenth century added the first four of the twelve symbols to the upper four roundels on the *long pao*.

Auspicious emblems

Symbolism plays an important role in the folklore of most societies, with certain objects or species being endowed

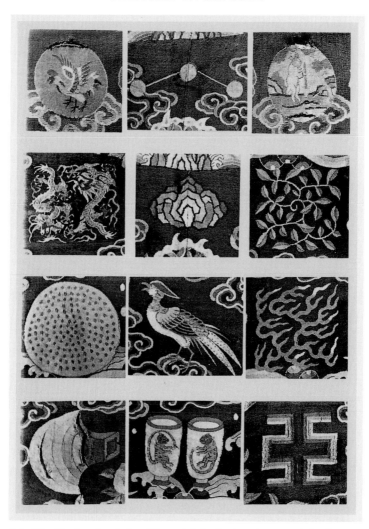

5.1 The Twelve Symbols of Imperial Authority, from top left: the sun disc with three-legged rooster, the constellation of stars, the moon disc with hare, the dragon, the mountain, the water weed, the grains of millet, the `flowery bird' or pheasant, the fire, the sacrificial axe, the sacrificial cups, and the *fu* symbol or Symbol of Discrimination.

with protective or propitious properties. The superstitious Chinese placed great faith in supernatural powers, and symbolism was employed in three ways: to invoke good fortune, to outwit the evil forces ever present, and to imply status. Very often combinations of these types were used together.

Throughout a succession of dynasties, becoming a wealthy and influential official was largely dependent on passing examinations founded on a thorough knowledge of the Chinese classics. This preoccupation with literary ability led to the making of subtle puns, based on the phonetic tones of the Chinese language. Rebuses (representations of words in the form of pictures or symbols) were used by many scholar officials and often indicated a high level of literary taste. In a country where the majority of the population was illiterate, visible and pictorial proof of rank, as well as of literary scholarship, demonstrated superior status. On the hem of an early eighteenth century yellow satin dragon robe (Plate 18) is a rebus in the form of a vase containing three halberds or pole-axes and a stone chime, together meaning, 'May you peacefully rise three degrees in rank.'

On most robes, surrounding the dragons were clouds, a *yang* element. Stylized clouds were a symbol of heaven and fertility, as well as being useful as space fillers and to unify a design. The shape of the clouds can be a useful guide in dating the robe. Long tapering clouds with pointed tails were used during the Ming and early years of the Qing dynasties, as is seen on the robe in Plate 9. They became fatter and more rounded towards the end of the nineteenth century (see Plate 17).

Good fortune was naturally aspired to by all and was epitomized by symbols for long life, abundance, and happiness. Bats were used frequently in the background of the

robes as the word *fu*, 'bat', is a homonym for 'happiness'. Five bats shown together signified the Five Blessings: longevity, health, wealth, virtue, and a natural death. A common rebus depicting a bat shown upside down means 'blessings have arrived', because the words for 'upside down' and 'arrived' are both pronounced *dao*. Plate 19 shows a detail from a turquoise robe, made in *kesi* and belonging to an imperial princess, with a bat holding coins. Coins were a symbol of, and of a desire for, wealth.

The character for long life, *shou*, can, it is said, be depicted in up to a hundred different ways. It appears increasingly on later robes. When combined with the bat it stands for long life and happiness. The crane is another longevity symbol, as the bird is said to live for two thousand years. A further emblem for long life is *wan*, one of the oldest design symbols in the world, said to have been associated with prehistoric shamanist rituals. Often confused with the swastika, it is taken to mean 'ten thousand years of long life'. *Xiangsi*, meaning 'double happiness', is depicted by the character *xi*, for happiness, repeated twice. As such, it is always associated with marriage and appears on dragon robes worn at weddings.

The latter half of the nineteenth century was a time of uncertainty in China. Propitious symbols used to summon favourable spiritual powers, and grouped together in sets of eight, cluttered up the backgrounds of the robes. Sometimes the full set of eight, itself a lucky number, was used, at other times a selection from the eight was made. The Eight Daoist Emblems, the fan, sword, gourd, castanets, flute, flower basket, a bamboo tube and divining rods, and a lotus pod, were symbols of the Daoist patron saints and were carried by the Eight Immortals. The Eight Precious Things, also known as the Eight Treasures, were the pearl for good fortune, the coin for wealth, the lozenge for victory, the

mirror for conjugal happiness, the stone chime for happiness, books for wisdom, rhinoceros horn cups for health, and Artemesia leaf for happiness.

The Eight Buddhist Emblems were the wheel of the law, the symbol of Buddhist teaching which leads the disciple to nirvana; the conch shell, originally used to call the faithful to prayer and a Buddhist symbol of victory; the umbrella, a symbol of nobility which sheds the heat of desire; the canopy, a symbol of victory over the religions of the world; the lotus flower, a symbol of purity and promise of nirvana; the jar, called the 'treasury of all desires' and said to contain the elixir of heaven; a pair of fish for happiness and the symbol of *yin* and *yang*; and the endless knot, symbolizing the Buddhist path and the 'thread' which guides one to happiness.

6

Other Robes with Dragons

WITH ITS POWERFUL and auspicious connotations, the dragon appeared on other garments as well as those worn by the Manchu rulers and their government officials. Wives of members of the Ming imperial family had worn dragon robes corresponding in rank to those of their husbands. However, the main dragons faced the opposite direction, the front one over the right shoulder and the rear one over the left, as is seen in Figure 6.1, showing the robe of the wife of a prince. Later, in the Qing dynasty, Han Chinese women adopted a type of dragon robe based on these worn in the Ming as a sign of homage and respect.

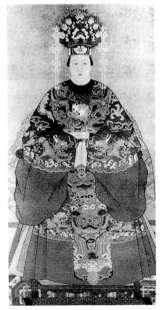

At first, wives of Chinese officials were expected to continue to wear Ming costume, but gradually the earlier conventions were forgotten and aberrations crept in. As persons of little consequence in the Manchu government, Han Chinese women, except those whose husbands or fathers were connected with the court in Beijing, were not required to wear any official attire. Most Chinese women were keen to show their

6.1 The wife of a Ming dynasty prince wearing a four-clawed dragon robe and *xia pei* with phoenixes.

national identity as pure Chinese and took care not to wear Manchu-style dress, except when they must accompany their husbands on official occasions and so wore a surcoat and insignia badge of the same rank.

On ceremonial occasions, when their husbands wore court dress, *chao fu*, Chinese noblemen's or high-ranking officials' wives would wear quasi-official formal dress. This consisted of the *mang ao*, a *xia pei* vest over it, a dragon skirt, and a coronet like that worn by their Ming predecessors.

Mang Ao

During the Qing dynasty, the Ming-style dragon robe became shorter to finish at mid-calf and became known as the *mang ao*, or dragon jacket. This was a loose-fitting jacket with bell sleeves, a plain round neck, and a side opening from neck to underarm like that of the Ming robes, and sometimes with side extensions, *bai*, to give greater bulk. This considerable use of silk fabric indicated the wealth of the family. Red, the dynastic colour of the Ming and therefore considered auspicious by the Chinese, was worn by the principal wife, blue by the second wife, and green by the third wife.

The *mang ao* was also worn by lower-ranking officials' wives as part of their bridal dress. Originally the jacket was undecorated, but portraits painted during the eighteenth century show that the jackets began to be decorated with dragons. Starting from the late eighteenth and early nineteenth centuries, between two and ten *mang* were embroidered according to status. A back view (Plate 20) shows the dispersion of seven of the ten dragons embroidered in couched gold thread. In the *li shui* border, peonies are embroidered in Peking knot. Towards the end of the Qing

dynasty, the *mang ao* became shorter and narrower and the *li shui* pattern was seldom used. The *mang ao* was worn over a panelled and pleated, brightly coloured skirt, often in red or green silk, called a *mang chu*, or dragon skirt. It had dragons depicted on the front and back panels and was first worn at the time of marriage, then afterwards for ceremonial occasions.

After the founding of the Republic in 1912, brides began to wear a slimmer, more fitted black satin jacket opening at the front, with a red or pink satin skirt (Plate 21). Both garments were decorated with auspicious flowers and birds as well as, and sometimes instead of, the dragon and phoenix. That, and a semblance of the *li shui* pattern of couched gold and silver thread, made for a very ornate and glittering style. After the wedding, the outfit would be worn at special events, including the Lunar New Year.

By the mid-twentieth century, the jacket was also made in red to match the skirt, and the outfit was called a *hong gua*. The dragon and the phoenix, a bird representing the empress and by extension the bride on her wedding day, predominated in the design, often with the couched metal threads covering the whole of the satin. Today most brides in Hong Kong and Taiwan wear the white wedding dress of Western style. But the traditional *hong gua* survives to be worn on the wedding day for kowtowing to the ancestors and both sets of parents, and for the banquet in the evening.

Xia Pei

The ceremonial, or court, robe worn by the Ming empresses had very wide sleeves almost sweeping the ground, and a plain neck fastening over to the right side with a long skirt. The robe, made of deep blue silk, was decorated with pairs

of pheasants, while bands of dragons edged the neck, cuffs, and hem.

Rank was denoted by an embroidered neckband which hung down over the chest and was decorated with gold and jade. This neckband was called a *xia pei*. It had been worn as far back as the fifth century AD and grew in popularity in the Sui (AD 581–618) and Tang dynasties. It was worn by members of the imperial family, as well as by wives of officials on ceremonial occasions, and was the forerunner to the ceremonial vest worn by Han Chinese women in the Qing dynasty. For the empress the neckband was decorated with dragons, imperial concubines and princesses wore phoenixes, while wives of noblemen and officials wore different birds or flowers.

In the Qing dynasty, the *xia pei* developed from the Ming stole into a wider, sleeveless tabard held together with tapes at the sides, reaching to below the knee and finishing with a fringe at the pointed hem. It was first worn on the wedding day, then afterwards at events of special importance connected with the husband's status (Fig. 6.2). The *xia pei* was decorated with profile dragons and *li shui*, and badges of rank like those of the wearer's husband were later incorporated on the front and back. At first the badges were embroidered onto the garment, but later empty spaces were left for them to be applied (Plate 22). A four-pointed 'cloud' collar, with the four lobes at chest, back, and over each shoulder, was incorporated into the *xia pei*, or else worn separately over the upper garment.

Dragon Jackets

Another form of dragon jacket is shown in Plate 23. These are not very common, nor are they easy to categorize. They

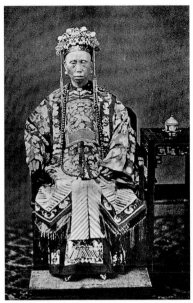

6.2 The wife of Huang Cantang, governor of Guangdong province, wearing a *xia pei*, *mang ao*, skirt, and phoenix crown, *c.*1862.

do not appear in the Regulations, but because of their similarity to dragon robes, with the inclusion of dragons and *li shui*, they are clearly intended for formal occasions. This may not mean they served as court dress for state occasions but rather at important events within the family such as weddings, possibly termed unofficial formal occasions. It is likely they were worn by Manchu women, as the proportions of the jacket indicate they were probably worn over a long gown. Personal preference would dictate their use, and the fact that they were cheaper to produce than a full-length robe may have added to their attractiveness.

Image Robes

Lastly, a further type of dragon jacket, looking very like a *mang ao*, was the image robe. These silk robes with dragons displayed over them were made to clothe statues in temples. Images were made in all sizes and so were the robes; as they were generally made oversized and often large enough for a human to wear, this can cause

confusion. They were made with very large sleeves fastening with tapes to enable them to be fitted more easily onto the image, or with extra openings if the hands of the idol were clasped together.

Schuyler Cammann notes, 'Huang Ti [Huangdi] and other legendary emperors of Chinese folklore traditionally were given yellow or crimson robes, deified officials commonly had dark red ones, while Kuan T'i [Guanyu] generally had his traditional green' (Cammann, 1952: 132). Most robes were made in the home or village, or commissioned for a specific deity, and the workmanship varied according to the wealth of the donor or importance of the temple deity.

Dramatic-looking dragons, with only four claws, were shown on these image robes until the end of Qing, when traditions broke down and five claws appeared. Plate 24 shows an image robe in yellowish green satin, embroidered at front and back with two large central front-facing dragons with four claws rising above two *qilin*, mythical beasts representing great wisdom, all embroidered in couched gold thread. There are four more profile gold dragons on the shoulders and back sleeves, with two more in satin stitch on the back *bai* extensions on the skirt. An inscription on the natural, callendered hemp lining reads: 'This robe was offered on the second day of the second month, the sixth year of Qianlong [1741]'.

7

Conclusion

As we have seen, robes with dragons on them, even though they began as purely informal robes during the Ming dynasty, became the highest form of official dress at court and within the government. Dragon robes were then adopted by rulers of the Qing dynasty and became an essential part of the wardrobe of the imperial court and the government officials. Their use declined with the fall of the Qing dynasty in 1911, although the Xuantong Emperor Puyi and members of the imperial family continued to wear them on formal occasions until their departure from the Forbidden City in 1924. The symbolism of the dragon still survives today in image robes for temple gods and in wedding attire for brides in Hong Kong and Taiwan.

It is tempting to try to pigeon-hole the robes to make them fit into pre-conceived categories, especially ones listed in the Regulations. In fact, this is difficult and quite often impossible. We may well ask, What is a standard dragon robe, anyway?

Most dragon robes are found today in the West, having been taken out of China at times of turmoil, such as the sacking of the Summer Palace in 1860 and the overthrow of the Qing dynasty in 1911, when Westerners resident in Beijing were able to buy dragon robes and court attire from noblemen wishing to raise capital. Many dragon robes made were never worn. Some did not hold up to the rigorous inspection of the Office of the Imperial Household and were discarded; others were surplus to requirements. Thus attributing provenance can be risky.

As so many are in relatively good condition, it raises the question, How were they cleaned? The short answer is

probably that they were not. Those that were in poor condition would not have been brought out of China by collectors and traders who, wishing perhaps to capitalize on their purchases, would have selected only the best. Other robes would have been destroyed, as owners would not have wanted to be associated with the decadent Qing court in the early days of the new Republic.

Many robes which have survived have been carefully preserved in museums. The Palace Museum in Beijing has probably the best collection of robes, but these are seldom on display. The National Palace Museum in Taipei has many court accessories but fewer garments. There are, however, several major museums in the West with collections of oriental art which include Chinese robes and textiles. The Royal Ontario Museum, Toronto, the Metropolitan Museum of Art, New York, and the Victoria & Albert Museum, London, all have important collections of dragon robes acquired in the early years of the twentieth century: viewing these is the best way to recognize quality. Additionally, the Museum of Art in Hong Kong and the Asian Civilizations Museum in Singapore have acquired dragon robes in more recent times.

For the aspiring collector, robes can be purchased from antique dealers or from major auction houses in the United States and Europe. Establish a good relationship with a dealer you trust and whom you feel is knowledgeable about the subject. Prices are rising as more collectors enter the field, and the ravages of time mean fewer quality pieces are available.

Before buying a robe, consider where you want to display it. A Plexiglas box, with ventilation holes to allow moisture to escape, is one option. Another is to hang the robe from a padded pole for short periods of time, but it should not hang where strong sunlight can cause fading,

nor should you place a spotlight over it. Robes sent by Ming rulers to Tibet five hundred years ago only saw the light of day again in the 1980s, when many were brought out of Tibet into Hong Kong. They were as fresh, in many cases, as the day they were made, due to being kept in the cool, dark, dry conditions of the monasteries. With care your robe will last and give pleasure for many more generations.

The Ming and Qing Emperors

The Ming Dynasty (1368–1644)

Hongwu	1368–1398
Jianwen	1399–1402
Yongle	1403–1424
Hongxi	1425
Xuande	1426–1435
Zhengtong	1436–1449
Jingtai	1450–1456
Tianshun	1457–1464
Chenghua	1465–1487
Hongzhi	1488–1505
Zhengde	1506–1521
Jiajing	1522–1566
Longqing	1567–1572
Wanli	1573–1620
Taichang	1620
Tianqi	1621–1627
Chongzhen	1628–1644

The Qing Dynasty (1644–1911)

Shunzhi	1644–1661
Kangxi	1662–1722
Yongzheng	1723–1735
Qianlong	1736–1795
Jiaqing	1796–1820
Daoguang	1821–1850
Xianfeng	1851–1861
Tongzhi	1862–1874
Guangxu	1875–1908
Xuantong (Puyi)	1909–1911

Sources of Illustrations

Photographs were provided by, or reproduced with the kind permission of, the following individuals or organizations. Care has been taken to trace and acknowledge the source of each illustration, but in some instances this has not been possible. Where omissions have occurred, the publishers will be pleased to correct them in future editions, provided they receive due notice.

Christies, South Kensington, London: Plate 20

The Commercial Press, Hong Kong: Figure 6.1

Valery Garrett: Plates 3, 6, 8, 10, 13, 14, 16, 17, 18, 19, 21, 22, 23; Figures 4.1, 4.2; cover illustration

I. T. Headland, *China's New Day* (Central Committee in the United Study of Christians, 1912): Figure 2.7

Jobrenco Ltd, Chris Hall Collection Trust: Plates 4, 9, 12, 15, 24; Figures 4.4, 4.5

Nanjing Museum, Nanjing: Plate 1, Figure 1.1

Nelson-Atkins Museum of Art, Kansas City, Missouri (Purchase: Nelson Trust): Figures 3.3, 4.3

Palace Museum, Beijing: Plates 2, 5; Figures 1.2, 2.2

Royal Ontario Museum, Toronto: Figure 3.1

Judith Rutherford: Plate 11

Teresa Coleman Fine Arts, Hong Kong: Plate 7

Victoria & Albert Museum, London (V & A Picture Library): Figures 2.1, 2.4, 2.6, 3.4

Bernard Vuilleumier: Figure 5.1

Selected Bibliography

Cammann, Schuyler (1952), *China's Dragon Robes*, New York: Ronald Press.

Der Ling, Princess (1914), *Two Years in the Forbidden City*, New York: Moffat, Yard & Co.

Dickinson, Gary, and Linda Wrigglesworth (1990), *Imperial Wardrobe*, Hong Kong: Oxford University Press.

Eberhard, Wolfram (1986), *A Dictionary of Chinese Symbols*, London: Routledge & Kegan Paul.

Garrett, Valery M. (1994), *Chinese Clothing: An Illustrated Guide*, Hong Kong: Oxford University Press.

Hong Kong Museum of Art (1995), *Heavens' Embroidered Cloths: One Thousand Years of Chinese Textiles*, Hong Kong: Urban Council of Hong Kong.

Vollmer, John E. (1977), *In the Presence of the Dragon Throne, Ch'ing Dynasty Costume (1644–1911) in the Royal Ontario Museum*, Toronto: Royal Ontario Museum.

———— (1980), *Five Colours of the Universe, Symbolism in Clothes and Fabrics of the Ch'ing Dynasty (1644–1911)*, Edmonton: The Edmonton Art Gallery.

———— (1983), *Decoding Dragons: Status Garments in Ch'ing Dynasty China*, Eugene: Museum of Art, University of Oregon.

Wade, H. T., ed. (1895), *With Boat and Gun in the Yangtze Valley*, Shanghai: Shanghai Mercury Office.

Wilson, Verity (1986), *Chinese Dress*, London: Victoria & Albert Museum.

Index

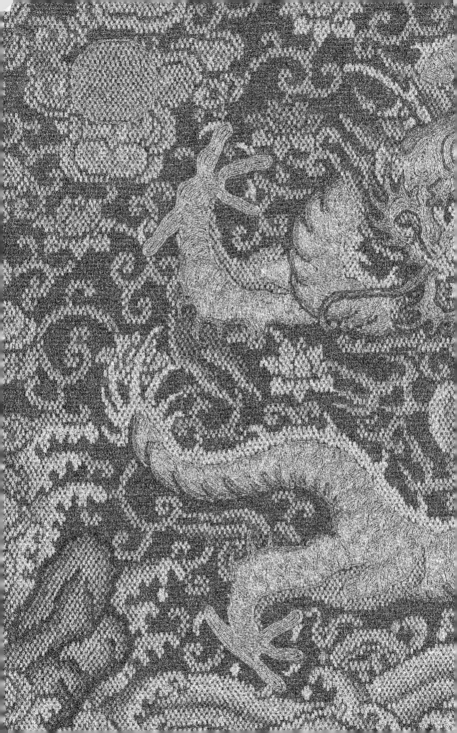